The Wandering in a Lost Mind

Hannah Tracy

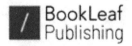

BookLeaf Publishing

The Art of Wandering in a Lost Mind ©
2022 Hannah Tracy

All rights reserved.

Presentation by *BookLeaf Publishing*

Web: www.bookleafpub.com

E-mail: info@bookleafpub.com

ISBN:978-93-95087-80-3

First edition 2022

Aquarius Part One

You look a lot like love
But shifted

Edges methodically erased and perfected
Like a movie I've seen before but
With an alternate ending

A puzzle with no pieces missing

A smile with no ill intention
And no brewing fear in my stomach

I don't have to choose my weapon this time

Combust

I was an accidental fire
A simple innocent burning flame
Written off and left unattended

A promise of a warm glow
Eventually engulfing all I touched
And turning to ash
Everything I once illuminated

Oh dear,
How a person can turn a home
into a hole

You

If I tell you that I love you

Know that I will fight for you
I will fight until my fingers bleed
And I cannot fight any longer

I will hold you up when
You cannot lift yourself

I will give you my faith
When you've lost yours

I must remind you,
You are the light that shines off of the moon at
night

You are the overtaking of the perfect melody
Pouring from car speakers
When you take a drive just to get away

You are magnificent
And no darkness will ever dull your shine

You are the embodiment of the love
That this universe has for this planet

Kintsukuroi

I am not damaged goods
The hands of Lady Galaxy
Picked up my pieces
And methodically mended each one
With molten liquid more magnificent
Than the suns she claims

Now I am whole,
Once again
And even stronger
than I began

Vagabond

I bleed gypsies blood
Mischief is my finest art
Their eyes locked on the glimmering
Purples and golds
On my fingers and throat

As I slither among them
Stealing their breath
And stealing the show

Showing my belly and keeping my head low
You made me your Master
Your deliverer
You dug your own grave

Fourth of July

The rain started the day you died
The sky cracked open
And the Universe sobbed

For days the storm rampaged
The clouds mourned you
For what seemed like forever

The sun lay in hiding
Surely broken by the disappearance
Of your presence
Under its light

The stars dimmed and aching
Without that face to glow upon
In the darkest part of night

If only you knew
The way they all treasured you

Puppet

First I objectified myself

I replaced myself
With doll parts
Painted rouge and ivory skin
I won their gifts
And all desire

Wind-up entertainment
For those who pay to play
A household name
Toy of the year
I go down in infamy

First I objectified myself
And then I crucified myself

A Broken Dream is a Jellyfish Sting

I'm wading in an ocean of disillusion
Expectation- my worst enemy
A continuous sixty foot wave
That keeps dragging me under

We lost sight of satisfaction long ago
A glimmering, sandy wedge of hope
On a horizon of deep blue
And frothy white suds of envy

Sometimes I try to swim
To get a glimpse of a shoreline

But sometimes I just float

Aquarius Part Two

You are not the first I have loved
I have known love that gave me butterflies
I have known love that was unrealistic
I have known love that changed me
I have known love that I didn't deserve
I have known love that made me a monster
I have known love that made me bleed
I have known love that was not allowed
I have known love that I do not remember

In this moment
I know a love that teaches me

I know a love like a lullaby

I know a love that feels like the mist from the
ocean gently passing by on a hot day

I know a love that exists not from a blazing fire,
but from a seedling, planted and tended,
Growing green and vast

I know a love that reminds me my heart is soft,
and I need not guard it

I know a love that needs no escape plan

You are not the first I have loved, no
But you are surely the last

The Great Death

When I get back up
Saddled onto my high horse

Or when someone
Blind eyes glimmering
Sets me up on that pedestal

I pray

That there is someone strong enough
In my life
To shoot me down

Suffrage circa 2022

My body is not your commodity
It is not a place you or your brothers
May call home

You may not bring it
To show and tell
To marvel in my abilities

My flesh is not your incubator
You may not use my power
For your personal will

I am not your pet
Nor your subject

You may carry the power
Of a pen to paper,
Of a twisted hive mind

But I carry the voices
And the strength
Of billions of creators
Of my sisters of present, past, and future

And let it be known

That we will not falter

Dogma

Do not tell me my dreams are unrealistic. Do not
shame me for being a dreamer. A dreamer of
harmony and togetherness and love.
Do not tell me a single voice cannot be heard
over the roar of the world.
Do not try to change my soft heart into one of
stone.
Do not try to silence me.
Do not tell me I will receive less because I don't
fit into the cookie cutter this world has made.
Do not tell me my fight is useless.
Do not tell me the war has been won already.
Do not tell me that money, hate, and divide is
what our world will always be made of.
Do not try to silence me.
Do not tell me I am too small to make a
difference.
Do not tell me unconditional love of all people is
naive.
Do not tell me I will never know peace because
of what I was born with between my legs.
Do not tell me people deserve to be treated as
less or harmed for the color of their skin.
Do not try to talk me out of my fight because
you are already cold and hardened and tired.

Do not try to silence me.
I do not tire.

Silver Tongue

My mind is my weapon
I sharpen my words like daggers
And hit you where your ignorance
Bleeds the most

The blank page is my battleground
Allowing years of trained tactics
Disassociation and dreaming
Lead me to the precipice of war

I wear ideas like armor
A sharp tongue
Stopping foes in their tracks
Questioning concepts
Illusion or fact

The walls of my psyche
Are of diamond
You may heal here
If you can get in

Dimethyltryptamine

One night I was visited by Khnum
He spoke in no language known to man
But his prophecy echoed through me
Like a prayer of a lone soul
Within the walls of an empty cathedral

He spoke of relief and release
Of water in the desert

His skin a kaleidoscope
Barely there
But completely overtaking
He is an iceberg in lone waters
No room for misinterpretation

He led without me knowing
As he did with Ra through the underworld
Allowing him to bring light to all beings
That inhabit this world of ours

History repeats itself
And I'm no longer in the dark

Flora

Mountains and valleys
I climb and I rest
A path others join me on
Occasionally

I watch them pass me up
And fall behind
Left with the mind-bending decision
To stay back with them
To lay in the valley of my discontent
Or continue trudging

We have no space for existentialism here
It distracts us from our journey
To continue to climb to an absolute unknown
Possibly to find

That the journey was the prize all along

Relapse to Incoherence

I made a trip back to the armory
To pick up my shell I had retired
The smile lines look just as real as ever
And the cracks are barely noticeable

The weight is nearly unmanageable
For my now novice muscles
But you wouldn't be able to tell

Because the eyes still glisten with joy
And full body armor doesn't show
That you're crying for help

Breach

Security and peace does not linger
He giveth and he taketh away

The quake of self doubt rushes and pours out of
every single orifice of my body and spills out in
front of me on the rug and I don't move

I search for an answer that may not even exist, in
a theory I made up, in a consciousness I have no
grip on

In my head, I'm angry and scared and I have the
power to change outcomes but in this reality I
just don't move

My brain is the best at burying a lost cause
It's also pretty good at digging them up

The fear, like a super charged magnet, pulls it all
out and again, still, I just won't move

Paroxysm

I put my trust in the way you broke me
It was the most honest thing you ever did

I had more faith in the inevitable
Ripping of flesh

Than I had in the way your voice cracked
Like twigs, under heavy feet
When you told me not to worry anymore

Pacify

The Devil stands on the sidelines
He is sometimes my biggest fan
He claps and he shames me
He kept me fed and he kept me strong
Reminds me why I play the game

He still doesn't realize
I'm switching teams

Malfunctioning

Dark inky sludge
Overpowering logic and sense
Reminding me of when I sharpened
My blood soaked claws
And used my words like weapons
A bittersweet longing
To feel a little less
And take a little more

The mind is our master
And it is designated to assist
Survive, Flourish, Exist

So tell me
Why is its' shaky fingertip
Softly lingering on the self destruct

Anima

I saw a vision
Of myself

Blank faced
And despondent
In my car
By the crystalline water

Sunset swirling
Melted cotton candy
as it does
In Florida at dusk

While flames engulfed us both

And for once my mind was still

Fade to black